To Aviva on her 5th Christmas! Here's a whole year of art for you made by you! Love, Lucy

MY YEAR OF ART

SUSAN SCHWAKE

ILLUSTRATED BY CHARLOTTE FARMER

THIS BOOK BELONG

D1280394

Kane Miller
A DIVISION OF EDC PUBLISHING

HELLO, ARTIST!

This book is a place for you to explore and practice your art ideas. The most important thing an artist can do is to **MAKE ART**—every day, if possible.

Inside there are 365 art activities. That's one for **EVERY DAY OF THE YEAR.** You'll be drawing, painting, writing, making collages, and much more. Some will take you seconds, while others might take much longer. You can complete them in any order, whenever you want, and however you like. Your answers are unique to you and that is what being an artist is all about—showing the world your own view.

JUST REMEMBER:

1. **BE BOLD**—this is a space to let your ideas run free.

2. Know that there are **NO** wrong answers, mistakes, or bad ideas.

3. Have fun! **ENJOY** the time you spend creating your art.

4. Once you're done, you'll have a **ONE-OF-A-KIND** record of your year.

SUSAN SCHWAKE

BEFORE YOU GET STARTED...

Here's a list of art materials to use as you fill in this journal:

- Pencil
- Eraser
- Ruler
- Ballpoint pen
- Black marker
- Colored markers
- Colored pencils
- Glue stick
- Scissors

- Set of watercolor paints
- Soft paintbrushes
- Wax crayons
- Washable ink pad
- White paper
- Scrap paper (old magazines or newspapers)
- Drinking straw
- Cotton swab
- Tinfoil

AVOID SMUDGES! Some activities involve using paint or ink. Make sure to keep the book open until your work has dried. Look for this icon to spot these activities.

MIX IT UP Sometimes an activity suggests what medium to use, such as markers. But if you feel like using something else, go ahead.

OFF THE PAGE If you find it tricky to draw, paint, or collage on the pages, you could do an activity on a separate piece of paper and glue it in the book afterward.

ASK FOR HELP You may need to use scissors for some activities. Make sure you ask an adult's permission beforehand.

1.

START THIS ART JOURNAL BY
DRAWING A PORTRAIT OF YOURSELF.

2.

CLOSE YOUR EYES. WHAT DO YOU SEE?
DRAW THE COLORS AND SHAPES.

3.

USING COLORED PENCILS, PICK FOUR
COLORS TO CREATE A PATTERN OR
PICTURE IN THE GRID BELOW.

4.

WHAT DID YOU HAVE FOR LUNCH
TODAY? DRAW IT HERE.

5.

IS IT POSSIBLE TO DRAW A PERFECT CIRCLE? PRACTICE HERE.

6. COLLECT SOME SCRAP PAPER AND TEAR IT INTO SMALL PIECES. USING A GLUE STICK, ARRANGE AND GLUE THE PIECES INTO A FLOWER SHAPE. USE MARKERS TO ADD DETAILS. COMBINING DIFFERENT MATERIALS TO MAKE ART LIKE THIS IS CALLED "COLLAGE."

7.

MANY ARTISTS ARE INSPIRED BY DREAMS. IN A DREAM, THINGS CAN SEEM BOTH FAMILIAR AND UNFAMILIAR AT THE SAME TIME. ARTISTS CAN SHOW THIS BY DISTORTING FAMILIAR OBJECTS—FOR INSTANCE, THEY MIGHT SHRINK OR ENLARGE THEM. SPANISH ARTIST SALVADOR DALÍ OFTEN DID THIS. SOME OF HIS PAINTINGS FEATURE MELTING CLOCKS OR ANIMALS WITH EXTRA-LONG LEGS.

TRY IT YOURSELF. PICK AN OBJECT AND DISTORT IT HOWEVER YOU LIKE. TAKE A LOOK AT THIS DALÍ-INSPIRED EXAMPLE TO HELP YOU.

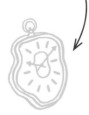

8. IMAGINE YOU'RE PETTING A DOG OR CAT. DRAW SOME LINES IN THIS BOX WITH A PENCIL TO SHOW HOW IT WOULD FEEL.

9.

LOOK OUTSIDE FOR AN
INSECT, OR IMAGINE ONE.
HOW DOES IT MOVE?
DRAW ITS PATH AND
SKETCH THE INSECT TOO.

10.

WATCH THE SUNSET OR FIND A
PICTURE OF ONE AND COUNT HOW
MANY DIFFERENT COLORS YOU SEE.
WRITE THEM HERE.

11. LOOK AT YOUR THUMBPRINT
AND DRAW IT INSIDE THE OVAL.

12. RUSSIAN ARTIST WASSILY KANDINSKY BELIEVED THAT COLOR AND SHAPES COULD EXPRESS FEELINGS AND SOUNDS. IN ONE PAINTING HE DREW A GRID FULL OF COLORFUL CIRCLES.

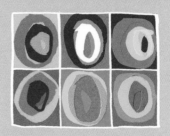

TAKE A LOOK AT THE KANDINSKY-INSPIRED EXAMPLE ABOVE, THEN USE CRAYONS TO CREATE YOUR OWN VERSION.

EXPERIMENT WITH THE SHAPES OF YOUR CIRCLES AND ADD COLOR TO THE BACKGROUND OF EACH SQUARE. THINK ABOUT HOW EACH COLOR AND SHAPE MAKES YOU FEEL.

13. PRETEND IT'S YOUR BIRTHDAY AND YOU CAN HAVE ANY KIND OF CAKE YOU LIKE. DRAW IT HERE. USE A PENCIL AND ADD COLOR WITH MARKERS.

14. MAKE UP AN IMAGINARY ANIMAL BY COMBINING TWO OR THREE OF YOUR FAVORITE ANIMALS. DRAW IT WITH COLORED PENCILS AND NAME IT.

15. THINK ABOUT THE ANIMAL YOU INVENTED IN ACTIVITY 14. WHERE DOES IT LIVE? DRAW IT IN ITS HABITAT.

16. IMAGINE A WINDY DAY. WHAT CAN YOU SEE? DRAW IT IN THE SPACE BELOW.

17. SHADE THE BOXES WITH THE COLORS YOU THINK REPRESENT THESE EMOTIONS:

HAPPY SAD ANGRY JEALOUS

18.

WHAT IS YOUR MOOD TODAY? USE A COLORED PENCIL TO SHADE THIS BOX IN A COLOR THAT REFLECTS HOW YOU FEEL. THEN WRITE A WORD THAT DESCRIBES YOUR MOOD ON TOP OF THE COLOR WITH A MARKER.

19.

LOOK AT A GLASS FILLED
WITH ICE CUBES.
NOTICE ALL THE COLORS
IN THE GLASS.

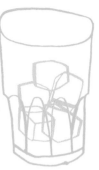

WRITE THEM HERE:

- - - - - - - - - - - - - - - - - - -

- - - - - - - - - - - - - - - - - - -

- - - - - - - - - - - - - - - - - - -

- - - - - - - - - - - - - - - - - - -

- - - - - - - - - - - - - - - - - - -

20.

USING A PENCIL,
CONTINUE ADDING
HEXAGONS TO FILL
THE SPACE. COLOR
THEM IN TO CREATE
A PATTERN.

21. DRAW YOUR PERFECT TREE HOUSE IN PENCIL IN THE SPACE BELOW.

22.

LOOK AROUND YOU. FIND
THREE THINGS THAT ARE RED
AND LIST THEM HERE.

23.

COLOR THESE BUGS IN BRIGHT COLORS. YOU
COULD ADD SPOTS, STRIPES, AND DETAILS.

24.

THESE LAMPS ARE MISSING THEIR SHADES. DRAW RANDOM OBJECTS
ON THE TOPS OF THE LAMPS INSTEAD AND ADD COLOR WHEN
YOU'RE DONE. LOOK AT THE EXAMPLE FOR INSPIRATION.

25.

TURN THIS BOOK UPSIDE DOWN
AND DRAW A PORTRAIT OF
SOMEONE IN THE FRAME.

26.

DESIGN A POSTER FOR
SOMETHING YOU BELIEVE IN.

27. DRAW THE PATH YOU TAKE TO WALK FROM YOUR
BEDROOM TO THE FRONT DOOR OF YOUR HOME.

28. DRAW YOUR FAVORITE CHARACTER FROM YOUR FAVORITE BOOK. DON'T FORGET ANY SPECIAL FEATURES OR PROPS.

29.

USING COLORED PENCILS, CREATE A DESIGN FOR THIS T-SHIRT, MADE UP ENTIRELY OF RECTANGLES.

30. WRITE YOUR FULL NAME IN CAPITALS ON THE LEFT
AND THEN WRITE IT BACKWARD ON THE RIGHT.

31. USING A BLACK MARKER, DRAW THREE OVALS IN THE SPACE BELOW. THEN
TURN EACH OVAL INTO A FACE SHOWING A DIFFERENT EMOTION. DON'T
FORGET THE EYEBROWS—THEY SHOW A LOT ABOUT HOW WE ARE FEELING.

32.
DESCRIBE WHAT
YOU THINK THESE
COLORS WOULD
TASTE LIKE.

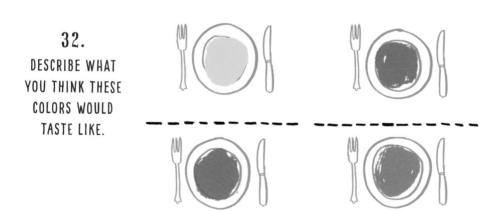

33.

LOOK AT ONE EYE UP CLOSE IN A MIRROR AND WRITE THE FIRST THREE WORDS THAT COME TO MIND.

1. _ _ _ _ _ _ _ _ _ _ _ _ _ _ _
2. _ _ _ _ _ _ _ _ _ _ _ _ _ _ _
3. _ _ _ _ _ _ _ _ _ _ _ _ _ _ _

34.

USE A PENCIL AND RULER TO DIVIDE THIS CIRCLE INTO EIGHT WEDGES. THEN USE A PENCIL IN YOUR FAVORITE COLOR TO SHADE ONE WEDGE AS LIGHTLY AS YOU CAN. WORKING CLOCKWISE, SHADE THE OTHER WEDGES USING THE SAME COLOR, MAKING EACH A LITTLE DARKER THAN THE ONE BEFORE. THIS IS CALLED A "GRADIENT."

35.

USING COLORED MARKERS, DESIGN A SOCK FOR EACH DAY OF THE WEEK.

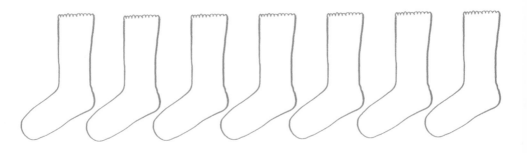

36. DIP A COTTON SWAB (OR A SIMILAR TOOL) INTO SOME PAINT AND CREATE A WAVY SEA OUT OF LITTLE DOTS BY DABBING THE COTTON SWAB ONTO THE PAGE. DOT ART LIKE THIS IS CALLED "POINTILLISM."

AVOID SMUDGES! KEEP THIS BOOK OPEN UNTIL THE PAINT HAS DRIED.

37.

USING A PENCIL, TRACE THE OUTLINE OF A KEY.

IF THIS KEY COULD OPEN ANY DOOR, WHICH DOOR WOULD IT BE?

38. IMAGINE YOU'RE RIDING ON A TRAIN AND SITTING BY THE WINDOW. WHAT DO YOU SEE? DRAW IT IN PENCIL AND ADD COLOR.

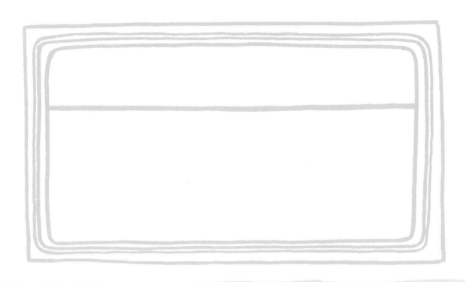

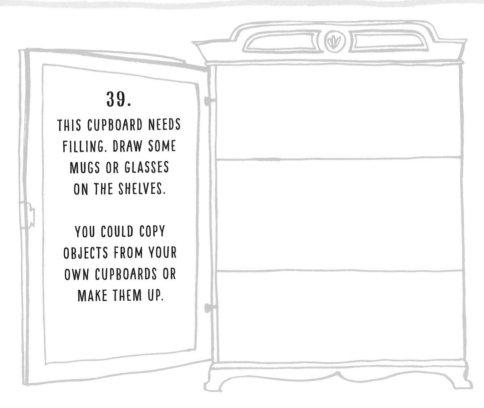

39.

THIS CUPBOARD NEEDS FILLING. DRAW SOME MUGS OR GLASSES ON THE SHELVES.

YOU COULD COPY OBJECTS FROM YOUR OWN CUPBOARDS OR MAKE THEM UP.

40.

USE A PENCIL TO SHADE THIS SQUARE COMPLETELY. NOW USE AN ERASER TO "DRAW" SOMETHING IN THE SQUARE.

41.

LOOK DOWN AT THE GROUND. WHAT DO YOU SEE? WRITE THREE THINGS THAT CATCH YOUR EYE.

1.
2.
3.

42.

DRAW AN ANIMAL USING ONLY SIMPLE SHAPES, SUCH AS CIRCLES, SEMICIRCLES, TRIANGLES, AND RECTANGLES. USE A BLACK MARKER.

43.

WHAT IS YOUR FAVORITE SEASON? DRAW AN OBJECT THAT SYMBOLIZES THAT SEASON, LIKE ICE CREAM FOR SUMMER.

44.

DIP A PAINTBRUSH IN SOME PAINT AND PRACTICE MAKING LOTS OF DIFFERENT MARKS, LINES, AND SWIRLS. TRY USING A FEW DIFFERENT BRUSHES TOO.

AVOID SMUDGES! KEEP THIS BOOK OPEN UNTIL THE PAINT HAS DRIED.

45. LOOK OUT THROUGH A WINDOW AND LIST SIX DIFFERENT COLORS YOU CAN SEE.

- - - - - - - - - - - - - - | - - - - - - - - - - - - -

- - - - - - - - - - - - - - | - - - - - - - - - - - - -

- - - - - - - - - - - - - - | - - - - - - - - - - - - -

46.

WRITE YOUR INITIALS AS LARGE AS POSSIBLE IN PENCIL. NOW TURN EACH LETTER INTO SOMETHING ELSE.

H ➤ (ladder) O ➤ (snail)

47. FILL EACH OF THESE TRIANGLES WITH A DIFFERENT PATTERN.

48.

DRAW A BIRD ON
THIS BRANCH IN PENCIL.
COPY ONE FROM A PHOTO
OR MAKE ONE UP.

49. LISTEN TO SOME MUSIC. USE A BLACK MARKER TO DRAW LINES THAT REPRESENT THE MUSIC.

50.

SWISS ARTIST PAUL KLEE SAID,
"A LINE IS A DOT THAT WENT
FOR A WALK." USE A PENCIL AND
TRY IT! WITHOUT TAKING YOUR
PENCIL OFF THE PAGE UNTIL
YOU'RE DONE, DRAW A FACE IN
ONE CONTINUOUS LINE.

51.

MAKE A SCRIBBLE IN THIS SPACE WITH A PENCIL. LOOK AT IT FROM ALL DIFFERENT ANGLES. DO YOU SEE ANYTHING IN THE SCRIBBLE? AN OBJECT OR A SHAPE? COLOR IN WHAT YOU SEE.

52.

DRAW THE OBJECT OR SHAPE THAT YOU FOUND IN THE SCRIBBLE IN ACTIVITY 51—BUT WITHOUT THE SCRIBBLE THIS TIME.

53. DRAW A DIFFERENT LITTLE CHARACTER ON EACH OF THESE TOES.

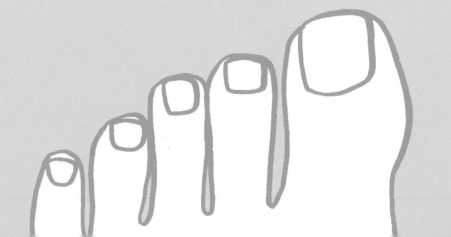

54.

DIP A FINGER IN YOUR FAVORITE COLORED PAINT AND USE IT TO WRITE A WORD IN THE SPACE. ONCE THE PAINT HAS DRIED, USE MARKERS TO ADD COLORFUL DETAILS AND DOODLES AROUND THE LETTERS.

 AVOID SMUDGES! KEEP THIS BOOK OPEN UNTIL THE PAINT HAS DRIED.

55.

LOOK AT AN ORANGE CLOSELY. DRAW THE TEXTURE YOU SEE ON THE OUTSIDE OF THE PEEL USING A PENCIL.

56.

WITH A PENCIL, DRAW A FACE WHERE ONE SIDE IS HAPPY AND ONE SIDE IS SAD.

57. LOOK AT A PIECE OF CLOTHING YOU ARE WEARING, AND DRAW ITS TEXTURE USING A PENCIL.

58.

A "HORIZON LINE" IS WHERE THE SKY MEETS THE LAND OR WATER. USE A PENCIL TO DRAW A HORIZON LINE IN THIS FRAME. ADD DETAILS OF WHAT IS HAPPENING IN THE SKY AND ON LAND OR IN THE WATER. ADD COLOR WITH CRAYONS.

59. YOU'VE DISCOVERED A NEW BUG SPECIES. DRAW IT BELOW. LIKE ALL INSECTS, IT SHOULD HAVE THREE PARTS TO ITS BODY AND SIX LEGS. EVERYTHING ELSE IS UP TO YOU.

60.
IMAGINE IF ELEPHANTS WERE THE SIZE OF DOGS! USE A PENCIL TO DRAW SOMEONE TAKING THEIR ELEPHANT FOR A WALK.

61.
FILL THIS SPACE WITH DRAWINGS OF SNAILS. USE A DIFFERENT COLORED MARKER FOR EACH ONE.

62. USING OLD, USED, OR DISCARDED PAPER AND A GLUE STICK, MAKE A COLLAGE OF SOMEWHERE WILD—IS IT A FOREST FLOOR? A SANDY DESERT? OR PERHAPS IT'S IN OUTER SPACE?

63. FIND A PICTURE OF A BICYCLE AND LOOK AT IT FOR TWO MINUTES. NOW DRAW THE BICYCLE FROM MEMORY IN THE SPACE BELOW.

64. USE THREE OF YOUR LEAST-FAVORITE COLORS TO DRAW AN IMAGINARY CREATURE. THEN GIVE IT A NAME.

65. THERE ARE MANY DIFFERENT KINDS OF WATER: WAVES, DROPS, POOLS, SPLASHES, AND SPRAYS. PRACTICE DRAWING AS MANY AS YOU CAN. THINK ABOUT THE DIFFERENT COLORS AND LINES YOU COULD USE FOR EACH ONE.

BRITISH ARTIST DAVID HOCKNEY OFTEN PAINTED WATER. TAKE A LOOK AT THIS HOCKNEY-INSPIRED EXAMPLE, THEN TRY DRAWING A SIMILAR SPLASH YOURSELF.

66. CHOOSE A BLUE OR PURPLE CRAYON. IN THE FIRST BOX, SHADE THE TOP SECTION OF THE BOX AS DARK AS YOU CAN, THEN MOVE DOWN THE BOX, MAKING IT LIGHTER AND LIGHTER AS YOU GO. TRY IT AGAIN IN THE SECOND BOX, GOING FROM LIGHT AT THE TOP, TO DARK AT THE BOTTOM. THIS TECHNIQUE IS CALLED "OMBRE."

67.
DRAW FIVE CIRCLES INSIDE THIS CIRCLE, GETTING SMALLER AND SMALLER. THESE ARE CALLED "CONCENTRIC CIRCLES." USE COLORED PENCILS, CHOOSING COLORS THAT EXPRESS HOW YOU FEEL RIGHT NOW. WRITE THE FEELING UNDER THE CIRCLE.

68. HERE IS A GIANT BOTTLE WAITING FOR YOU TO DRAW A WHOLE WORLD IN IT. SHOW WHAT IS HAPPENING ABOVE AND BELOW THE GROUND WITH COLORED PENCILS.

69. DESIGN AN INVENTION THAT COULD HELP SOMEONE YOU KNOW, LIKE AN ALARM CLOCK YOU HAVE TO CATCH, FOR A FRIEND WHO CAN NEVER GET UP IN THE MORNING!

70.

USING A COLORED MARKER, DRAW A LINE IN THIS FRAME FROM ONE EDGE TO ANOTHER. DO THE SAME AGAIN WITH A DIFFERENT COLORED MARKER. CONTINUE DRAWING THE LINES, EACH IN A DIFFERENT COLOR, UNTIL YOU'RE HAPPY WITH THE PICTURE.

71. FILL THIS REFRIGERATOR WITH ALL YOUR FAVORITE FOODS.

72.

"ABSTRACT ART" IS ART THAT DOESN'T TRY TO REPRESENT OR COPY REALITY. FOLLOW THE STEPS TO MAKE AN ABSTRACT PORTRAIT.

1. FLICK THROUGH AN OLD MAGAZINE UNTIL YOU FIND A FACE THAT CAN FIT IN THE RECTANGLE TO THE LEFT.

2. CUT OR TEAR THE FACE INTO HORIZONTAL STRIPS.

3. JUMBLE THE STRIPS INTO A NEW ORDER.

4. GLUE YOUR ABSTRACT FACE INSIDE THE BOX.

73.

DRAW SOMETHING CRUNCHY IN THIS SPACE.

74. IMAGINE IF COWS HAD WINGS. WHAT WOULD THEY LOOK LIKE? USE A BLACK MARKER TO DRAW A BUNCH OF COWS WITH DIFFERENT KINDS OF WINGS: FEATHERY WINGS, TINY BUTTERFLY WINGS, AIRPLANE WINGS—GET CREATIVE.

76.

FIND A COIN AND LOOK AT THE TWO SIDES. WHICH DESIGN DO YOU LIKE MOST? DRAW IT IN PENCIL AND ADD COLOR.

75.

DRAW A FLOWER WITH ONE HAND AND A VASE FOR IT WITH YOUR OTHER HAND. USE A MARKER.

77.

YOU ARE EXPLORING SOME ANCIENT CAVES.
DRAW WHAT YOU SEE ON THE CAVE WALLS.

78. AMERICAN ARTIST GEORGIA O'KEEFFE OFTEN PAINTED FLOWERS. SHE WOULD
DRAW THEM VERY CLOSE UP SO THAT THEY FILLED THE WHOLE CANVAS.

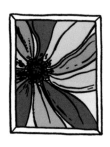

TRY IT YOURSELF. DRAW A
FLOWER SO LARGE THAT IT
CAN'T FIT IN THE FRAME.
COLOR IT WITH MARKERS
OR CRAYONS. USE THIS
O'KEEFFE-INSPIRED
EXAMPLE TO HELP YOU.

79.

SLUGS, SPIDERS, AND SNAKES—THESE ARE CREATURES THAT SOME PEOPLE DON'T LIKE. HOW COULD YOU MAKE THEM CUTER? REINVENT THEM IN THE SPACE BELOW.

80.

THINK OF SOMETHING WITH A SHINY SURFACE. DRAW THE OBJECT YOU THINK OF.

81.

WRITE DOWN WHAT COLORS THESE WORDS MAKE YOU THINK OF:

WARM

WET

FROSTY

COOL

82.

IN THE FOUR BOXES, DRAW THE SAME TREE AS IT WOULD APPEAR IN SUMMER, FALL, WINTER, AND SPRING. USE COLORED PENCILS.

83. WITH A BLACK MARKER, DRAW THE LINES AND SHAPES YOUR FEET WOULD MAKE IF YOU WERE ICE-SKATING.

84. DRAW YOUR PET (REAL OR IMAGINARY) USING A BLACK MARKER.

85.

DRAW SOME VEGETABLES USING ONLY SMALL CIRCLES AND OVALS.

86.

DRAW A SNOWMAN... IN THE HOT DESERT!

87. WRITE YOUR NAME IN PEN IN THIS SPACE, OVER AND OVER, TO FILL IT UP. ADD YOUR FAVORITE COLORS TO THE WHITE SPACES LEFT.

88.

MAKE A SMALL DOODLE IN THE FIRST BOX WITH A MARKER. DRAW THE SAME DOODLE AGAIN IN THE NEXT TWO BOXES, USING A DIFFERENT COLOR FOR EACH ONE. YOU COULD USE A DIFFERENT MEDIUM FOR EACH ONE TOO, SUCH AS A PENCIL AND A CRAYON.

89. DRAW A DIFFERENT HAT ON EACH OF THESE PEOPLE.

90.

USE COLORED PENCILS AND FILL IN THE PICTURE. COLOR THE BALLOON WITH VERTICAL LINES; USE HORIZONTAL LINES FOR THE SKY AND DIAGONAL LINES FOR THE SUN.

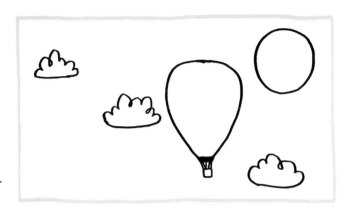

91. LOOK AROUND YOU. ARE THERE ANY PLACES THAT ARE FULL OF LIGHT AND OTHERS THAT ARE DARK? WRITE DOWN THE LIGHTEST AND DARKEST AREAS.

LIGHT DARK

92.

YOUR PET BIRD HAS ESCAPED TO THE MOON! DRAW IT IN ITS NEW HOME.

93.

PUT AN ICE CUBE ON A PLATE AND DRAW IT IN PENCIL IN THE FIRST BOX.
WAIT FIVE MINUTES AND DRAW THE ICE CUBE AGAIN IN THE SECOND BOX, THEN
WAIT FIVE MORE MINUTES AND DRAW IT AGAIN IN THE FINAL BOX. WRITE
A WORD BELOW EACH BOX THAT DESCRIBES THE PICTURE ABOVE IT.

94.

STAINED GLASS WINDOWS
CAN SHOW PEOPLE AND
SYMBOLS AS WELL AS
ABSTRACT DESIGNS.
LOOK AT THE EXAMPLE
BELOW, THEN USE A BLACK
MARKER TO DESIGN YOUR
OWN WINDOW. ADD COLOR
TO BOTH WINDOWS.

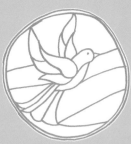

95.

LOOK AT THE REPEATING PATTERN BELOW, THEN TRY DRAWING YOUR OWN. PICK TWO SHAPES OR OBJECTS AND DRAW THEM IN ANY ORDER YOU CHOOSE. THEN REPEAT.

☆☾☆☾☆☾☆☾

96.

LOOK AROUND THE ROOM YOU'RE IN FOR A WHILE. NOTICE HOW YOUR EYES JUMP FROM ONE OBJECT TO ANOTHER, AND HOW THEY FOLLOW LINES. WRITE DOWN THE THREE OBJECTS YOUR EYES KEPT GOING TO THE MOST.

97.

IMAGINE YOU'RE A SPIDER. DRAW YOURSELF AND YOUR WEB WITH COLORED MARKERS.

98.

DRAW YOUR FAVORITE
FRUIT AND YOUR FAVORITE
ANIMAL. COLOR IN YOUR
DRAWINGS, BUT SWAP
THE COLORS AROUND. FOR
EXAMPLE, YOU COULD END UP
WITH A GREEN ZEBRA AND
A STRIPY PEAR!

99. LISTEN TO YOUR FAVORITE SONG. NOW HUM IT TO YOURSELF
AND DRAW WITH CRAYONS HOW IT MAKES YOU FEEL.

100. DRAW A BRIDGE BETWEEN THESE TWO ISLANDS.

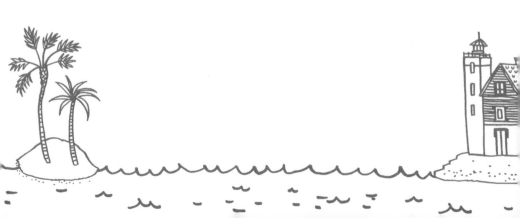

101.

USING COLORED
MARKERS, DRAW
A VERY FANCY
OUTFIT ON
THIS GIRAFFE.

WHEN YOU'RE
HAPPY WITH THE
OUTFIT, COLOR
IN ANY PARTS
OF THE GIRAFFE
THAT AREN'T
COVERED AND
ADD DETAILS TO
ITS FACE.

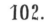

102.

DRAW TWO BOTTLES ON
THIS SHELF. DRAW THEM AT
THE SAME TIME, WITH A
PENCIL IN EACH HAND!

103.

ALL SNOWFLAKES HAVE SIX POINTS.
DRAW ONE HERE IN PENCIL.

104.

COLLECT SOME OLD PAPER. CUT OR TEAR IT INTO SMALL PIECES. STICK THE PIECES DOWN TO MAKE A COLLAGE OF AN OBJECT YOU CAN HOLD IN YOUR HAND.

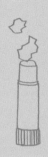

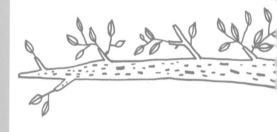

105.
IMAGINE YOU ARE A BIRD. DRAW ONE OF YOUR FEATHERS.

106.
DRAW SOMETHING DANGLING ON THE BRANCH. HOW ABOUT A SLEEPY SLOTH? OR A SWARM OF BEES?

107.

USING A PENCIL, DRAW AN IMAGINARY LAND INSIDE THIS CANVAS. SHOW WHAT TIME OF DAY IT IS AS WELL AS THE SEASON. USE MARKERS TO ADD COLOR.

108. PEOPLE DON'T KNOW FOR SURE WHAT COLORS THE DINOSAURS WERE, SO WHEN ARTISTS DRAW THEM, THEY MAKE IT UP! NOW IT'S YOUR TURN. COLOR THIS TRICERATOPS HOWEVER YOU LIKE.

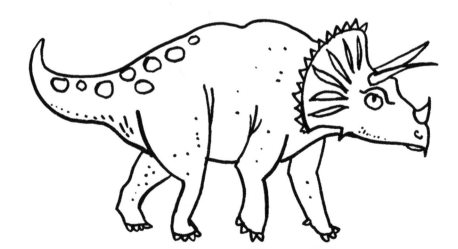

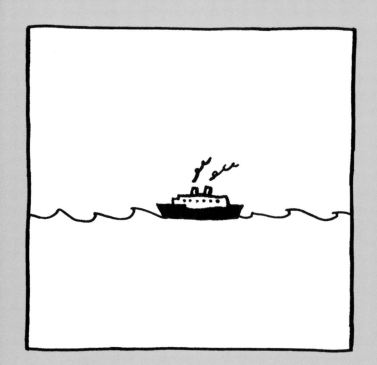

109.

LOOK AT THE BOAT IN THIS PICTURE. DRAW A BOAT BEHIND IT AND A BOAT IN FRONT OF IT. THINK ABOUT PERSPECTIVE AND MAKE SURE THE BOAT FARTHEST AWAY IS THE SMALLEST AND THE BOAT CLOSEST IS THE BIGGEST.

110.

"MOBILES" ARE MOVING SCULPTURES THAT OFTEN HANG FROM CEILINGS.

DESIGN YOUR OWN MOBILE. WITH A PENCIL, DRAW AN OBJECT OR SHAPE HANGING FROM EACH EMPTY POINT. ADD COLOR WITH MARKERS.

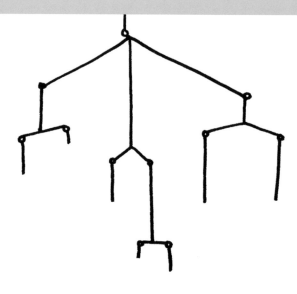

111. USING A PENCIL, DRAW THREE VEGETABLE FRIENDS. MAKE SURE TO GIVE THEM FACES AND SHOW WHERE THEY ARE.

112. PICK A WORD AND A COLOR THAT EACH REPRESENT THE FEELING OF BEING COZY. WRITE AND SHADE THEM BELOW.

113.
IMAGINE IF RAINDROPS WERE ALL DIFFERENT COLORS. DRAW A COLORFUL RAIN SHOWER.

114.

LOOK OUT THE WINDOW AND DRAW THE CLOSEST THING YOU SEE AT THE BOTTOM OF THE WINDOW. THEN DRAW THE FARTHEST THING YOU SEE BEHIND IT AT THE TOP OF THE WINDOW. NOTICE THE COLORS. THINGS FARTHER AWAY APPEAR MORE SUBDUED.

115.
DESIGN YOUR DREAM BEDROOM. YOU COULD DRAW A PLAN LOOKING DOWN INTO YOUR ROOM, OR YOU COULD DRAW THE FURNITURE AND OBJECTS YOU WOULD HAVE.

116.

PLACE A SHEET OF PAPER ON TOP OF A MATERIAL THAT YOU'RE ALLOWED TO GET MESSY (LIKE SOME OLD NEWSPAPER OR A PIECE OF CARDBOARD). DIP A PAINTBRUSH INTO SOME WATERED-DOWN PAINT, HOLD THE BRUSH OVER THE PAPER WITH ONE HAND AND TAP IT WITH THE OTHER TO CREATE SPATTER AND DRIPS ON THE PAPER. DO THIS THREE TIMES, USING A DIFFERENT COLOR PAINT EACH TIME. THIS IS CALLED "ACTION PAINTING." AMERICAN ARTIST JACKSON POLLOCK PAINTED IN THIS WAY.

WHEN THE PAINT HAS DRIED, CUT OUT A 6-INCH HIGH BY 5-INCH WIDE RECTANGLE AND GLUE IT HERE ON TOP OF THIS GRAY RECTANGLE.

117. IMAGINE YOU HAVE BEEN ASKED TO BUILD A SNOW SCULPTURE. SKETCH YOUR DESIGN IN THE SPACE BELOW.

118.

IMAGINE IT'S RAINING OUTSIDE. DRAW THE PATTERN OF RAINDROPS ON YOUR WINDOW.

119. DRAW TWO RECTANGLES BELOW. PICK A COLORED PENCIL AND SHADE ONE USING ONLY HORIZONTAL LINES AND THE OTHER USING ONLY VERTICAL LINES.

120.

WHAT DOES A SHY PERSON LOOK LIKE? MAKE A QUICK SKETCH HERE.

121.

FIND A PICTURE OF A PUMPKIN AND DRAW IT BELOW WITH AN ORANGE MARKER. USE A GREEN MARKER TO SHADE THE DARKER AREAS.

122.

FILL THIS BURGER BUN WITH WHATEVER YOU LIKE.

123.

WRITE A SHORT WORD BELOW. LEAVE SOME SPACE BETWEEN THE LETTERS. NOW ADD LINES TO TURN THE WORD INTO A DRAWING OF SOMETHING.

124.

CUT OUT A FACE FROM
AN OLD MAGAZINE AND
GLUE IT ON THIS PAGE.
NOW FLICK THROUGH
THE MAGAZINE TO
FIND OBJECTS SHAPED
SIMILARLY TO THE EYES,
NOSE, MOUTH, AND
EARS, AND GLUE THEM
ON THE FACE.

125. PICK AN OBJECT AND DRAW IT IN THE BOXES BELOW.

SPEND 1
MINUTE DRAWING.

SPEND 5
MINUTES DRAWING.

SPEND 10
MINUTES DRAWING.

126.
DRAW SOMETHING ON THE ICEBERG.

127.
FILL IN THE REST OF THE SCALES ON
THIS FISH AND THEN COLOR THEM
IN WITH COLORED MARKERS.

128.
FILL IN THE SQUARE BELOW WITH A
WHITE CRAYON. THEN USE A PALE-
BLUE MARKER TO COLOR OVER THE
TOP OF THE WHITE SQUARE. THE
CRAYON WILL RESIST THE MARKER.

129.
THESE EMPTY
SHELVES ARE MISSING
SOMETHING. USE
A PENCIL TO
FILL THEM UP.

130. BE A TEXTURE DETECTIVE! LOOK AROUND YOU AND TRY TO
FIND AND LIST THREE ITEMS WITH THE FOLLOWING TEXTURES:

BUMPY

-
-
-

SMOOTH

-
-
-

SCRATCHY

-
-
-

131.
DRAW SOMETHING IN
THIS SPACE, USING
EVERY COLOR OF
CRAYON YOU HAVE.

132.
CREATE A WINDING, TWISTING PATH USING ONLY STRAIGHT LINES INSIDE THIS BOX—NO CURVES ALLOWED.

133. MANY ARTISTS DRAW EVERYDAY OBJECTS. LOOK IN YOUR HOME FOR AN OBJECT SUCH AS A CLOCK, A BOOK, OR A PENCIL CUP. SIT IN FRONT OF THE OBJECT AND DRAW IT WITH A PENCIL.

134.
IMAGINE YOU AND AN ANT HAVE SWAPPED SIZES. DRAW YOURSELF AND THE ANT NEXT TO EACH OTHER.

135. A STORM IS COMING! DRAW THE CLOUDS, LIGHTNING, AND RAIN BELOW.

136.
DRAW THE FOLLOWING TEXTURES:

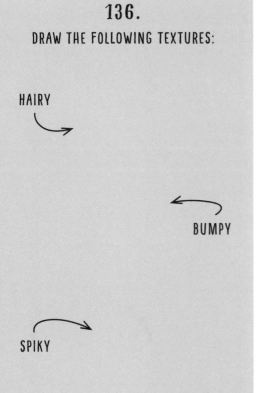

HAIRY

BUMPY

SPIKY

137.
USING A COLORED MARKER, MAKE A RING AROUND EACH OF THE DOTS IN THIS CIRCLE. CONTINUE MAKING MORE RINGS, IN DIFFERENT COLORS, GETTING LARGER EACH TIME, UNTIL YOU REACH THE EDGE OF THE OUTSIDE CIRCLE.

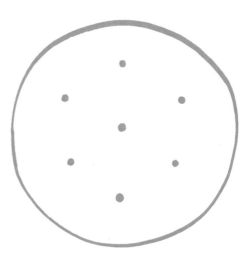

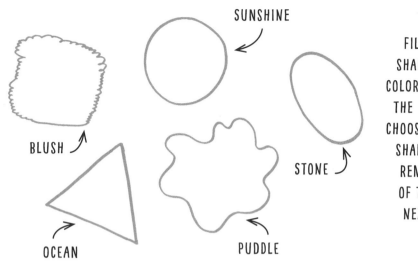

SUNSHINE

BLUSH

OCEAN

PUDDLE

STONE

138.

FILL IN THE SHAPES USING COLORED PENCILS. THE COLOR YOU CHOOSE FOR EACH SHAPE SHOULD REMIND YOU OF THE WORD NEXT TO IT.

139.

ROLL UP A PIECE OF PAPER LIKE A TELESCOPE. LOOK AROUND THE ROOM OR PLACE YOU'RE IN. STOP WHEN YOU SPOT A GOOD VIEW AND DRAW IT IN THE CIRCLE TO THE RIGHT.

140. YOU ARE RULER OF THE WORLD! WHAT DOES YOUR CASTLE LOOK LIKE? DRAW IT HERE WITH A PENCIL.

141.

CREATE A PICTURE IN THE GRID BY DRAWING LINES BETWEEN THE DOTS.

142.

DRAW SOME CIRCLES THAT OVERLAP EACH OTHER. ONLY COLOR IN THE SPACES WHERE THE CIRCLES OVERLAP.

143.

BE A FASHION DESIGNER.
DESIGN A WHOLE OUTFIT
INCLUDING A HAT, SHOES,
AND ACCESSORIES.

144. SAY YOUR NAME OUT LOUD. NOW WRITE IT IN CAPITAL LETTERS, MAKING THE
LETTERS YOU EMPHASIZE WHILE SPEAKING ALOUD LARGER AND THICKER.

145. FIND A PICTURE OF SOME WOOD GRAIN AND DRAW IT WITH A PENCIL
IN THE FIRST CIRCLE. DRAW IT AGAIN WITH A CRAYON IN THE SECOND
CIRCLE AND WITH A MARKER IN THE THIRD CIRCLE. COMPARE.

1.

2.

3.

146. THIS IS AN EMPTY BEACH AT THE WATER'S EDGE. DRAW SOME PEOPLE IN THE WATER AND ON THE BEACH. THE ONES FARTHER AWAY SHOULD APPEAR SMALLER THAN THE ONES CLOSER TO THE VIEWER.

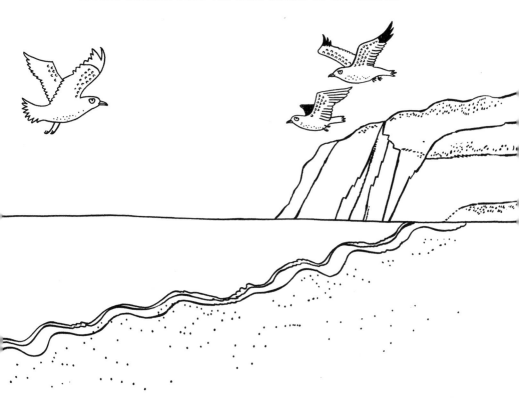

147.
DESIGN A NEW LOGO FOR YOUR FAVORITE SPORTS TEAM.

148. USING A PENCIL, CREATE A NEW HAIRDO FOR YOUR FAVORITE ADULT.

149.

USING COLORED MARKERS, DRAW A GUITAR USING ONLY STRAIGHT LINES.

150. FILL THIS SQUARE BY CHOOSING A SINGLE LETTER AND DRAWING IT REPEATEDLY IN DIFFERENT SIZES, DIRECTIONS, AND STYLES UNTIL THERE'S NO MORE ROOM.

151.

WHAT WAS THE MOST MEMORABLE THING YOU SAW TODAY? WHY WAS IT MEMORABLE? WRITE YOUR ANSWERS HERE:

152.

KNOWN FOR HER COLORFUL LANDSCAPE PAINTINGS, AMERICAN ARTIST JOAN MITCHELL FILLED HER CANVASES WITH FRENZIED BRUSHSTROKES.

TRY PAINTING LIKE MITCHELL. USING PAINT AND A SMALL PAINTBRUSH, FILL THE FRAME USING QUICK, SHORT BRUSHSTROKES IN ALL DIRECTIONS AND PLENTY OF COLOR. USE THIS MITCHELL-INSPIRED EXAMPLE TO HELP.

AVOID SMUDGES! KEEP THIS BOOK OPEN UNTIL THE PAINT HAS DRIED.

153.

GIVE THESE COLORS THE BEST DESCRIPTIVE NAME YOU CAN THINK OF. TRY NOT TO USE THE ACTUAL NAME IN YOUR DESCRIPTION. FOR EXAMPLE, VIOLET COULD BE CALLED "JUICY GRAPE." THINK HARD!

154. FIND A MAP OF THE WORLD SHOWING ALL THE CONTINENTS. NOW IMAGINE YOU DISCOVERED A PLANET. DRAW A MAP OF THIS NEW WORLD'S CONTINENTS.

155.

YOU'RE INVITED TO A COSTUME PARTY. DRAW YOUR OUTFIT HERE.

156.

WITH A PENCIL, DRAW THE ELEMENTS OF A FACE (EYES, EYEBROWS, NOSE, LIPS, EARS) IN THE MIDDLE OF THE BOX. THEN CREATE THE SHAPE OF THE HEAD BY FILLING IN THE BACKGROUND WITH LINES THAT END WHERE THE EDGE OF THE HEAD STARTS.

YOUR PICTURE SHOULD END UP LOOKING SOMETHING LIKE THIS.

157. WHAT WOULD A GOLDFISH LOOK LIKE IF IT WERE LIVING ON LAND? DRAW YOUR VISION IN THE SPACE BELOW.

158.

FIND A PICTURE OF A TREE TRUNK—OR RUB YOUR HAND OVER ONE IN REAL LIFE IF YOU CAN. NOTICE THE TEXTURE. DRAW IT HERE.

159. AMERICAN ARTIST FAITH RINGGOLD IS KNOWN FOR HER STORY QUILTS. TRY MAKING YOUR OWN BELOW. THINK OF A STORY YOU WANT TO TELL— IT COULD BE A MEMORY. DRAW A PICTURE THAT TELLS THE STORY IN THE CENTRAL RECTANGLE, THEN ADD DIFFERENT PATTERNS, SHAPES, AND COLORS IN THE SMALLER RECTANGLES TO CREATE A BORDER.

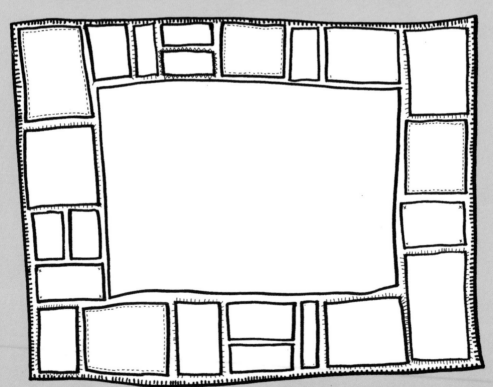

160. YOU HAVE DISCOVERED A DESERTED ISLAND. MAKE A MAP OF YOUR ISLAND IN PENCIL. WHERE IS YOUR SHELTER? ARE THERE MOUNTAINS, TREES, AND LAKES? PERHAPS THERE'S BURIED TREASURE.

161.

USE COLORED MARKERS TO TURN THESE SPOONS INTO A FAMILY. ADD FACES, LIMBS, AND CLOTHES.

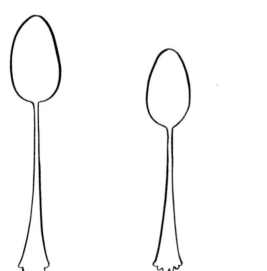

162.

SOUTH AFRICAN ARTIST ESTHER MAHLANGU IS KNOWN FOR HER COLORFUL GEOMETRIC PAINTINGS. HER WORK IS INSPIRED BY HER CULTURE.

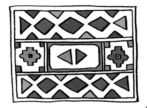

MAKE YOUR OWN GEOMETRIC ART LIKE MAHLANGU IN THE FRAME BELOW. TRY TO USE SHAPES AND COLORS THAT ARE MEANINGFUL TO YOU. USE THIS MAHLANGU-INSPIRED EXAMPLE TO HELP.

163. THINK OF SOMETHING WITH A MATTE (DULL) SURFACE. DRAW THE OBJECT HERE.

164.

THIS LITTLE BEAR CUB
NEEDS A PAL. DRAW
THEM A FRIEND.

165. WHAT SHAPES DO YOU SEE WHEN YOU THINK OF THE FOLLOWING THINGS?
USE A PENCIL TO SKETCH EACH SHAPE YOU THOUGHT OF.

1. A BUILDING 2. A SLIDE 3. A BOWL OF FRUIT

166. DRAW A STREET FULL OF HOUSES. SEE IF YOU CAN MAKE EACH ONE LOOK
DIFFERENT. THINK ABOUT WINDOWS, DOORS, CHIMNEYS, BRICKS, AND ROOFS.

167. THESE KIDS HAVE LOST THEIR HEADS! CUT OUT THREE OBJECTS FROM AN OLD MAGAZINE AND GLUE EACH ONE WHERE THE HEAD SHOULD BE.

168.

DRAW WHAT YOU'D FIND INSIDE THIS OLD CHEST.

169.

USING COLORED PENCILS, LIGHTLY FILL IN THESE CIRCLES. USE THE LABELS TO KNOW WHAT COLOR TO USE FOR EACH CIRCLE. NOTICE THE DIFFERENT COLORS THAT APPEAR IN THE OVERLAPPING SECTIONS.

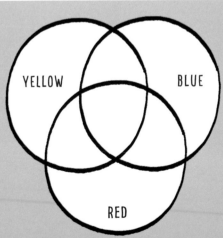

YELLOW

BLUE

RED

170.

DRAW SOME FLOWERS COMING OUT OF THE TOP OF THIS VASE. THEN TURN THE BOOK UPSIDE DOWN AND DRAW FLOWERS COMING OUT FROM THE BOTTOM. THEN DECORATE THE VASE.

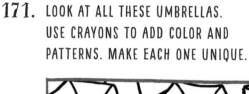

171.

LOOK AT ALL THESE UMBRELLAS. USE CRAYONS TO ADD COLOR AND PATTERNS. MAKE EACH ONE UNIQUE.

172.

USE A BLACK MARKER TO DRAW A TRIANGLE MADE UP OF LOTS OF TIDY LITTLE CIRCLES.

173.

FILL THIS EMPTY JAR WITH COLORFUL CANDIES. USE COLORED PENCILS AND A BLACK MARKER TO OUTLINE THEM. COUNT THEM UP WHEN YOU'VE FINISHED. HOW MANY ARE THERE? WRITE THE NUMBER HERE.

174.

CHOOSE A LETTER OF THE ALPHABET. LOOK FOR THIS LETTER IN A VARIETY OF OLD MAGAZINES AND NEWSPAPERS. CUT OUT THREE DIFFERENT VERSIONS OF THE LETTER THAT YOU LIKE AND GLUE THEM HERE.

175. LOOK CLOSELY AT A PIECE OF FRUIT THAT IS CUT IN HALF. DRAW ALL THE SHAPES YOU CAN SEE.

176. DRAW THE CROWN YOU'D WEAR IF YOU WERE A QUEEN OR KING. GLUE ON PIECES OF FLATTENED TINFOIL TO ADD SOME SHINE IF YOU LIKE. YOU CAN ALSO ADD COLOR TO THE TINFOIL WITH MARKERS.

177.

DRAW SOMETHING UNEXPECTED IN THIS BATHTUB.

178.

TAKE A COIN OR A PAPER CLIP AND PLACE IT BEHIND THIS PAGE. MAKE SURE IT'S PLACED DIRECTLY UNDER THE RECTANGLE BELOW. THEN, USING A PENCIL OR A CRAYON, RUB THE PAGE OVER THE TOP OF THE OBJECT. DO THIS A FEW TIMES—YOU SHOULD SEE THE OUTLINE OF THE OBJECT APPEAR. THIS TECHNIQUE IS CALLED "FROTTAGE."

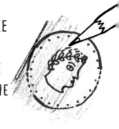

179.

ADD ALL THE ELEMENTS OF A FACE TO THIS HEAD—BUT REARRANGE THEM SO THEY APPEAR IN DIFFERENT PLACES. YOU COULD PUT THE NOSE ON THE FOREHEAD OR DRAW THE EYES ON THE CHEEKS—IT'S UP TO YOU.

180.

DRAW A SHAPE THAT FITS YOUR CURRENT MOOD. WRITE YOUR NAME AND THE DATE INSIDE THE SHAPE. ADD COLOR TOO. USE MARKERS.

181.

IN THE SPACE BELOW, DRAW THE FIRST THING THAT COMES
TO YOUR MIND WHEN YOU THINK OF ... THE SUN.

182.

TURN THESE BORING HOUSEHOLD OBJECTS
INTO EXCITING SUPERHEROES.

183.

USING COLORED PENCILS, TURN THIS OVAL SHAPE INTO A BUNNY FACE. ADD EARS, A NOSE, A MOUTH, EYES, AND WHISKERS.

184.

A TRACTOR IS PLOWING IN THE FIELD. DRAW THE TRACKS IT MAKES USING COLORED MARKERS.

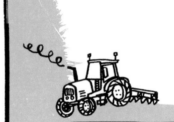

185.

DRAW A DIFFERENT PLANT IN EACH OF THE POTS. CHOOSE A VARIETY OF LEAVES, COLORS, AND TEXTURES. USE A PENCIL AND COLORED MARKERS.

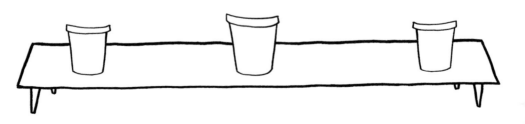

186.

WHICH ACTIVITIES, OBJECTS, OR THINGS DO EACH OF THESE LINES MAKE YOU THINK OF?

WRITE AN ANSWER NEXT TO EACH LINE.

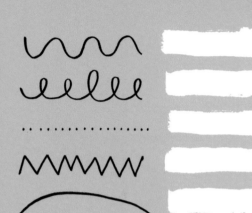

187.

FIND SOME PICTURES OF DIFFERENT ANIMALS' EYES. NOTICE THE VARIETY OF COLORS AND SHAPES. FILL EACH OF THE CIRCLES BELOW WITH A DIFFERENT EYE. YOU CAN BASE THEM ON YOUR RESEARCH OR SIMPLY MAKE THEM UP.

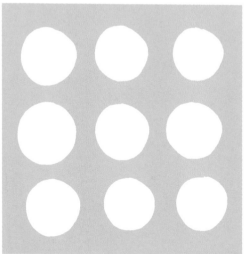

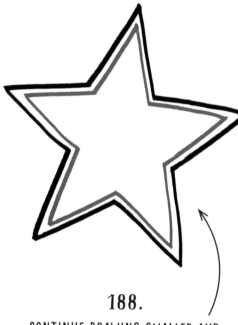

188.

CONTINUE DRAWING SMALLER AND SMALLER STARS INSIDE THIS STAR, UNTIL YOU CAN'T DRAW ANY MORE. USE A DIFFERENT COLORED PENCIL FOR EACH STAR YOU DRAW, OR PICK THREE COLORS TO REPEAT.

189. DRAW SOMETHING IN EACH OF THE WINDOWS BELOW. YOU COULD DRAW PEOPLE, ANIMALS, MONSTERS, PLANTS—ANYTHING YOU LIKE.

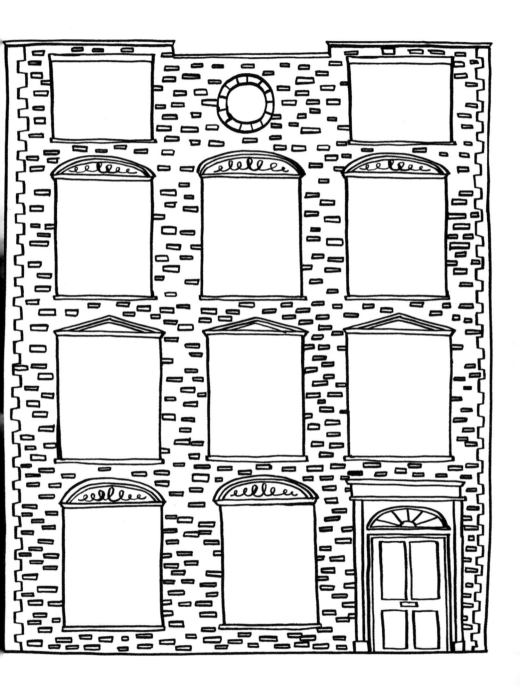

190.

DRAW THE FIRST LETTER OF YOUR NAME IN THIS OVAL, LEAVING SPACE AROUND IT. FILL THE REMAINING SPACE WITH DRAWINGS OF THINGS THAT YOU LIKE OR ARE MEANINGFUL TO YOU.

192.

USING A PENCIL, DRAW SOMETHING THAT WOULD NORMALLY BE HUGE IN THE PALM OF THIS HAND.

191.

YOU WANT TO START A CLUB ABOUT YOUR FAVORITE ACTIVITY. DESIGN A PATCH THAT EXPRESSES WHAT YOUR CLUB IS ALL ABOUT. USE COLORED PENCILS.

193. DRAW TWO DIFFERENT SEASHELLS. YOU COULD FIND SOME PICTURES TO HELP YOU OR JUST USE YOUR IMAGINATION.

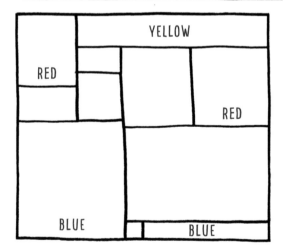

194.

PIET MONDRIAN WAS A DUTCH ARTIST. HE OFTEN USED PRIMARY COLORS DIVIDED BY BLACK LINES. TRY IT YOURSELF. JUST FILL IN THE SHAPES ABOVE WITH THE LABELED COLORS, LEAVING THE UNLABELED SHAPES BLANK.

195.

WRITE DOWN THE SECOND THING YOU THINK OF WHEN YOU LOOK AT EACH COLOR BELOW.

 - - - - - - - - - - - - - -

- - - - - - - - - - - - - -

 - - - - - - - - - - - - - -

 - - - - - - - - - - - - - -

196. USING A PENCIL, DRAW SOMETHING ON TOP OF THE BRIDGE AND SOMETHING UNDER IT. USE COLORED PENCILS TO FINISH THE PICTURE.

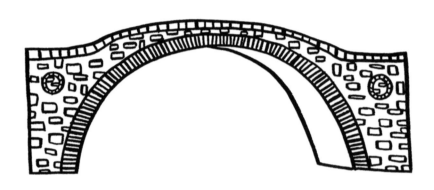

197. HATCHING AND CROSSHATCHING ARE TECHNIQUES USED TO CREATE TONE AND SHADE BY DRAWING PARALLEL LINES. PRACTICE THE TECHNIQUES BY REPEATING EACH STEP.

STEP 1 STEP 2 STEP 3 STEP 4 FINAL

198.

PRESS A FINGER ONTO AN INK PAD. MAKE A FEW PRINTS IN THIS SPACE, THEN USE COLORED MARKERS TO TURN THE PRINTS INTO BUGS. YOU COULD ADD WINGS, LEGS, ANTENNAE—IT'S UP TO YOU.

 AVOID SMUDGES! KEEP THIS BOOK OPEN UNTIL THE INK HAS DRIED.

199. LOOK AT THE SKY. WHAT COLORS CAN YOU SEE? RECORD THEM HERE.

200.

CREATE A STRIPED PATTERN ON THIS SHIRT USING YOUR FAVORITE COLORS.

201.

USING A PENCIL, DRAW SOMEONE OR SOMETHING SITTING ON THIS FLYING CARPET. ADD COLOR.

202.

MONOGRAMS ARE FANCY WAYS OF ARRANGING THE INITIALS OF YOUR FIRST, MIDDLE, AND LAST NAMES. DRAW YOURS IN THESE FRAMES.

203.

USE A BLACK MARKER TO MAKE 20 RANDOM DOTS IN THIS SPACE. NOW CONNECT THEM USING A COLORED MARKER.

204.

SCRUNCH UP SOME OLD NEWSPAPER INTO A BALL SMALL ENOUGH TO FIT IN YOUR PALM. DIP THE BALL IN GREEN PAINT AND PRESS IT ON THE PAGE TO MAKE A TREE. ONCE THE PAINT IS DRY, ADD THE TRUNK AND OTHER DETAILS USING MARKERS.

AVOID SMUDGES! KEEP THIS BOOK OPEN UNTIL THE PAINT HAS DRIED.

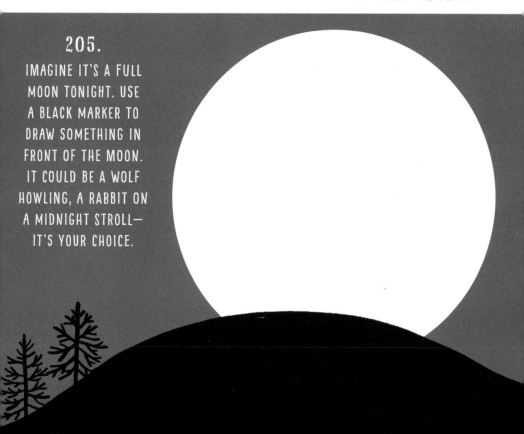

205.

IMAGINE IT'S A FULL MOON TONIGHT. USE A BLACK MARKER TO DRAW SOMETHING IN FRONT OF THE MOON. IT COULD BE A WOLF HOWLING, A RABBIT ON A MIDNIGHT STROLL— IT'S YOUR CHOICE.

206.

FIND THREE SMALL, FLAT OBJECTS, SUCH AS LEAVES, BUTTONS, OR COINS. PRESS ONE SIDE OF EACH OBJECT ONTO AN INK PAD, THEN PRINT THEM BELOW HOWEVER YOU LIKE. TRY PRESSING DOWN WITH DIFFERENT PRESSURES TO SEE THE DIFFERENT EFFECTS.

AVOID SMUDGES! KEEP THIS BOOK OPEN UNTIL THE INK HAS DRIED.

207. USE A COLORED PENCIL TO FILL IN EVERY PART OF THE ROOM BELOW. THEN USE A BLACK MARKER TO ADD POLKA DOTS ALL OVER THE ROOM.

JAPANESE ARTIST YAYOI KUSAMA ONCE CREATED A SIMILAR ROOM IN AN ART GALLERY THAT VISITORS COULD EXPLORE. THINK ABOUT HOW YOU MIGHT FEEL IN A ROOM WHERE ALL YOU COULD SEE WERE LOTS OF BLACK DOTS.

208.

DRAW THREE DIFFERENT KITES. USE CRAYONS FOR COLOR AND A BLACK MARKER FOR DRAWING.

209.

DRAW SOME USEFUL THINGS YOU COULD KEEP IN A TOOLBOX— THEY DON'T HAVE TO BE TOOLS.

210. DRAW A LINE TO GO WITH EACH OF THESE WORDS...

SLOW

FAST

UP

DOWN

211. YOU ARE GOING ON A PICNIC. DRAW ALL THE SNACKS YOU WANT TO BRING.

212.
TAPE TWO OR THREE PENCILS TOGETHER. PRACTICE DRAWING DIFFERENT SWIRLS AND LINES IN THIS SPACE, THEN TRY DRAWING AN OBJECT.

213. HERE IS A BIG EGG THAT JUST HATCHED. USING A PENCIL, DRAW THE ANIMAL INSIDE IT.

214. THINK ABOUT A HAPPY MEMORY AND DRAW YOUR HAPPIEST FACE AS LARGE AS YOU CAN. YOUR EARS AND HAIR SHOULD TOUCH THE SIDES OF THE FRAME.

215. SOME KIDS HAVE COME TO THE AQUARIUM, BUT IT'S EMPTY. DRAW A HUGE UNDERWATER CREATURE FOR THEM TO LOOK AT. ADD LOTS OF DETAIL AND COLOR.

216. CREATE A ROCKET SHIP THAT YOU'LL FLY TO THE MOON. DRAW IT WITH A BLACK MARKER AND USE CRAYONS FOR COLOR.

217.

CUT OUT A SMALL FLOWER PETAL SHAPE FROM A SCRAP OF PAPER. TRACE AROUND IT TO CREATE PETALS ON THE FLOWER STEM BELOW. ADD COLOR WITH MARKERS.

218.

DRAW A CAT ON THIS RUG. THINK ABOUT ITS STANCE. IS IT SLEEPING, OR MAYBE GETTING READY TO POUNCE?

219.

MAKE A LIST OF ALL
THE GREEN THINGS
YOU SAW TODAY.

220.

PICK AN OBJECT TO DRAW.
NOW SET A TIMER FOR FIVE
MINUTES AND USE A PENCIL TO
DRAW THE OBJECT IN AS MUCH
DETAIL AS YOU CAN. STOP WHEN
THE TIMER GOES OFF.

221. DID YOU DREAM ANYTHING LAST NIGHT? OR HAVE
ANY DAYDREAMS TODAY? USING A BLACK MARKER,
DRAW WHAT YOU REMEMBER IN THIS SPACE.

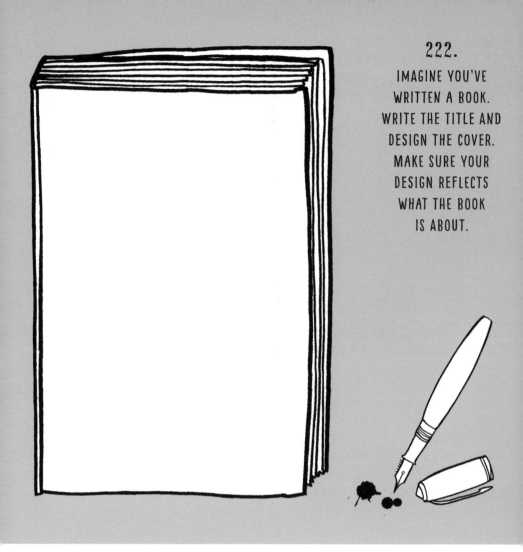

222.

IMAGINE YOU'VE WRITTEN A BOOK. WRITE THE TITLE AND DESIGN THE COVER. MAKE SURE YOUR DESIGN REFLECTS WHAT THE BOOK IS ABOUT.

223.

USING COLORED MARKERS, FILL IN THE THREE EGGS. ADD PATTERNS, STRIPES, AND SPOTS. MAKE EACH ONE UNIQUE.

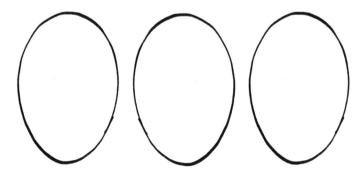

224.

IMAGINE THAT AN ART GALLERY HAS ASKED YOU TO FILL AN ENTIRE ROOM WITH AN OBJECT THAT MEANS SOMETHING SPECIAL TO YOU. YOU COULD PICK ONE LARGE OBJECT, SUCH AS A CAR, OR MILLIONS OF COPIES OF A TINY OBJECT, SUCH AS A SUNFLOWER SEED. WHAT OBJECT WOULD YOU PICK? DRAW IT IN THE CIRCLE AND EXPLAIN WHAT IT MEANS TO YOU.

225.

DRAGONS BREATHE FIRE AND WHALES SPURT WATER. BUT TODAY IS OPPOSITES DAY! DRAW WATER SPRAYING FROM THE DRAGON'S MOUTH AND FIRE SHOOTING UP FROM THE WHALE'S BLOWHOLE. THEN COLOR IN THE CREATURES.

226. USING A PENCIL, DRAW A PORTRAIT OF THE HAIRIEST THING YOU HAVE EVER SEEN OR IMAGINED.

227. THIS GIFT IS FOR YOUR FAVORITE PERSON. COLOR THE BOX AND RIBBON, THEN ADD PATTERNS OR DRAWINGS TO MAKE IT PERFECT.

WHO IS THE GIFT FOR?

WHAT'S INSIDE THE BOX?

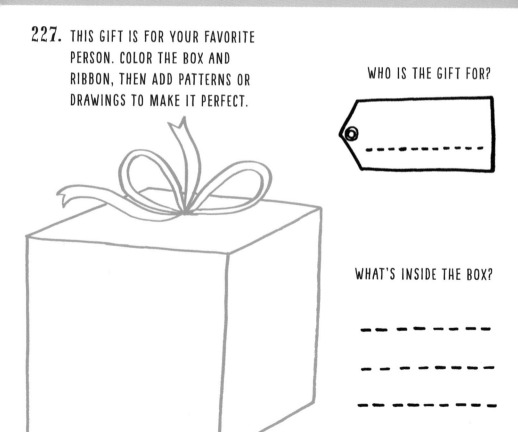

228.

YOU'RE GOING TO A MASKED BALL. DECORATE YOUR MASK ANY WAY YOU LIKE.

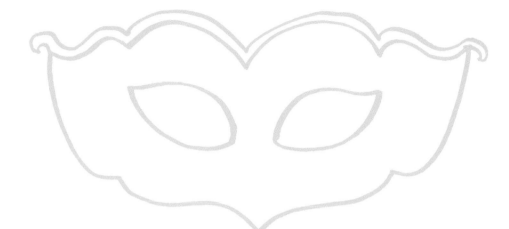

229.

YOU HAVE WON FIRST PRIZE FOR YOUR CREATIVITY! DRAW YOUR TROPHY BELOW.

230.

THERE ARE SIGNS WITH SYMBOLS EVERYWHERE. CREATE A SYMBOL OF YOUR OWN ON THIS SIGN.

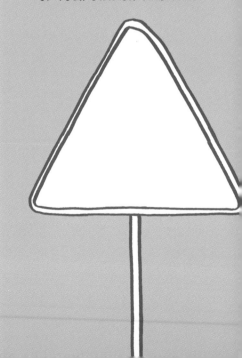

231.

WHAT DO YOU THINK OF WHEN YOU HEAR THE WORD "WATER"? DRAW IT IN THE RECTANGLE.

232. DRAW A LAUGHING MOUTH, WITH TEETH AND A TONGUE, IN THE SPACE BELOW. MAKE IT FILL THE WHOLE FRAME.

233.

YOU HAVE BEEN GRANTED ONE WISH! DRAW IT IN PENCIL IN THE SPACE TO THE LEFT.

234. CONTINUE ADDING TRIANGLES TO FILL THIS SPACE. ADD COLOR TO MAKE A PATTERN.

235. USING A PENCIL, DRAW A PERSON WHO IS VERY SLEEPY. THINK ABOUT WHAT SHOWS SLEEPINESS IN A PERSON'S FACE OR BODY.

236.

DRAW AN OCTOPUS WITH ALL EIGHT TENTACLES—EACH ONE HOLDING A DIFFERENT ITEM! USE A PENCIL FOR THE DRAWING AND MARKERS FOR THE COLOR.

237.

DRAW SOMETHING ON EACH SIDE OF THE SCALE. USE COLORED MARKERS.

238.

PLACE A SMALL DROP OF WATERED-DOWN PAINT ON THIS SPACE AND GENTLY BLOW ON IT THROUGH A STRAW. TRY BLOWING IN DIFFERENT DIRECTIONS.

AVOID SMUDGES! KEEP THIS BOOK OPEN UNTIL THE PAINT HAS DRIED.

239. FIND A SMALL PEBBLE AND LOOK AT IT CLOSELY. DRAW IT WITH COLORED PENCILS. TRY TO CAPTURE ALL ITS COLORS AND MARKINGS.

240. DESIGN A FANCY PAIR OF GLASSES FOR A ROCK STAR. USE COLORED PENCILS AND MARKERS. YOU COULD ADD JEWELS, PATTERNS, TASSELS, COLORED GLASS—THE CHOICE IS YOURS.

241. DESIGN A BOAT TO TAKE YOU AND YOUR FRIENDS ON AN OCEAN VOYAGE. USE A PENCIL AND COLORED MARKERS.

242. WHAT IF CATS WENT TO SCHOOL? USING A PENCIL, DRAW THE CATS IN CLASS.

243.

DESIGN A UNIFORM FOR AN
OUTDOOR ADVENTURE CLUB.

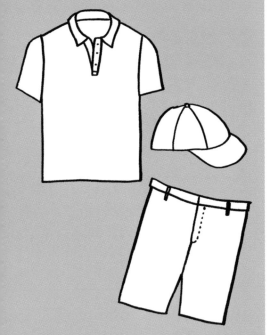

244.

WHAT WOULD YOU GROW IN
THIS WINDOW BOX? IT DOESN'T
HAVE TO BE FLOWERS.

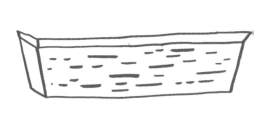

245.

WITH A PENCIL, DRAW YOUR FAVORITE THREE ANIMALS STANDING ON TOP OF EACH OTHER, STARTING WITH THE LARGEST AT THE BOTTOM AND THE SMALLEST ON TOP.

246.

DRAW YOURSELF AS SOMETHING YOU WOULD LIKE TO BE WHEN YOU'RE AN ADULT.

247.

YOU'RE SCUBA DIVING AROUND A SHIPWRECK. DRAW THE TREASURES YOU FIND HERE.

248. DRAW A SUNNY DAY OUTSIDE THE FIRST WINDOW AND A RAINY DAY OUTSIDE THE SECOND. NOTICE THE DIFFERENCE IN COLORS.

249.

PRACTICE MAKING 3-D SHAPES BELOW.

250.

WHAT WOULD IT LOOK LIKE IF A MOUSE LIVED INSIDE A SEASHELL LIKE A HERMIT CRAB? DRAW IT HERE WITH COLORED PENCILS.

252.

THINK OF A BROWN ANIMAL. NOW
DRAW IT IN A NEW, BRIGHTER COLOR.

251.

IN THIS BOX, CREATE A PATTERN
USING ONLY BLUE TRIANGLES
AND YELLOW CIRCLES.

253.

DUTCH ARTIST VINCENT VAN GOGH'S FAMOUS PAINTING "STARRY NIGHT"
SHOWS STARS TWINKLING IN A NIGHT SKY. HIS SWIRLING LINES GIVE
THE ILLUSION THAT THE STARS ARE MOVING. FOLLOW THE STEPS TO
DRAW SOME STARS LIKE HE DID. FILL THE SPACE WITH THEM.

1. START WITH A
SMALL CIRCLE.

 o

2. ADD DASHES
SWIRLING
AROUND IT.

254.

WITH AN ADULT'S HELP, TAKE A SLICE OF CARROT (OR ANOTHER VEGETABLE) AND PRESS IT ONTO AN INK PAD. PRINT A PATTERN IN THIS SPACE, THEN ADD DETAILS AND COLOR WITH MARKERS.

AVOID SMUDGES! KEEP THIS BOOK OPEN UNTIL THE INK HAS DRIED.

255.

FILL THIS SPACE WITH ALL DIFFERENT KINDS OF SHOES—FANCY ONES, MAGIC ONES, GLASS ONES, FLYING ONES! USE A PENCIL TO DRAW AND MARKERS FOR COLOR.

256.

DESIGN THIS PENNANT TO REPRESENT YOU. YOU COULD INCLUDE YOUR FAVORITE COLORS, AN ANIMAL YOU LIKE—WHATEVER YOU THINK MAKES YOU, YOU.

258.

DRAW SOMETHING EMERGING FROM THIS HAT.

257.

IT'S THE YEAR 2050 AND YOU HAVE INVENTED SOMETHING THAT HELPS PEOPLE EVERYWHERE. DRAW IT HERE.

259. IMAGINE THAT EVERYTHING IN THE WORLD IS MADE OF YOUR FAVORITE COLOR. DRAW SOME OF THE PEOPLE, OBJECTS, BUILDINGS, AND WILDLIFE.

260. AMERICAN ARTIST JEFF KOONS IS FAMOUS FOR HIS SCULPTURES OF GIANT BALLOON ANIMALS. THEY ARE MADE FROM STAINLESS STEEL (NOT ACTUAL BALLOONS!). TRY DRAWING SOME YOURSELF. USE BOLD AND BRIGHT COLORS.

261.

WRITE DOWN WHAT YOUR BIGGEST DREAM IS INSIDE THE CLOUD, THEN COLOR IT HOWEVER YOU LIKE.

262. USE A PIECE OF TINFOIL TO MAKE A TINY MODEL OF A PERSON. POSE THE MODEL AND DRAW IT IN THIS SPACE.

263. YOU'VE BEEN ASKED TO DESIGN A ROUND HOUSE. DRAW IT HERE WITH A PENCIL AND ADD COLOR.

264.

IS THERE A MUSICAL
INSTRUMENT YOU CAN,
OR YOU WISH YOU
COULD, PLAY? FIND A
PHOTO OF IT AND DRAW
IT WITH A PENCIL.

265. MAKE A LIST OF ALL THE YELLOW THINGS YOU HAVE SEEN TODAY.

- --
- --
- --
- --

266.

DRAW WHAT
THIS TIGER IS
DREAMING.

267.

PLACE A SMALL OBJECT ON A TABLE. NOW DRAW IT FROM TWO DIFFERENT VIEWPOINTS WITH A PENCIL. FIRST LOOK DIRECTLY DOWN AT IT AND DRAW. THEN LOOK AT IT SIDE-ON AND DRAW. USE THE EXAMPLE TO HELP YOU.

268.

USING A MARKER, DRAW A PERSON WITH YOUR EYES CLOSED. ADD AS MUCH DETAIL AS YOU CAN BEFORE OPENING YOUR EYES.

269.

LOOK AT THE SHAPES BELOW. USING ONLY THESE SHAPES, CREATE AN OBJECT OF YOUR CHOICE. YOU MAY USE THE SHAPES AS MANY TIMES AS YOU LIKE.

270. RENAME THE OBJECTS BELOW. THE NEW NAMES SHOULD BE INSPIRED BY WHAT THE OBJECTS LOOK LIKE. YOU COULD USE COMBINATIONS OF WORDS THAT ALREADY EXIST, OR INVENT BRAND-NEW ONES.

RULER

PINEAPPLE

LAMP

TELEPHONE

271.
DESIGN YOUR VERY OWN CAR. IS IT BASED ON ONE IN REAL LIFE OR IS IT A FANTASTICAL INVENTION?

272.
DRAW THE MOST EXCITING PLACE YOU HAVE EVER BEEN TO.

273. FOLLOW THE STEPS TO DRAW A PICTURE OF A ROAD WINDING INTO THE MOUNTAINS. USE A PENCIL.

1. DRAW THE HORIZON LINE, ROAD, AND ROAD MARKINGS.

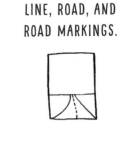

2. ADD IN TREES— LARGE ONES IN FRONT—AND MAKE THEM SMALLER AS YOU WORK BACK.

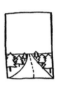

3. ADD MOUNTAINS, CLOUDS, AND COLOR.

274. FIND SOME STRING, RIBBON, OR A SIMILAR ITEM AND PLACE IT IN FRONT OF YOU. MAKE SURE THAT IT LOOPS IN A WAY THAT YOU LIKE. DRAW IT IN PENCIL BELOW. LOOK FOR DARK AND LIGHT AREAS TO SHADE IN.

275.

CREATE A SCULPTURE BY PILING
A FEW DIFFERENT OBJECTS
ON TOP OF EACH OTHER. USE
SMALL, STURDY OBJECTS—
NOTHING TOO FRAGILE IN CASE
THEY TOPPLE OVER. WHEN
YOU'RE SATISFIED WITH YOUR
SCULPTURE, SKETCH IT IN
PENCIL HERE.

276.

MAKE UP A NEW ANIMAL WITH
THREE LEGS AND DRAW IT IN PENCIL.

277.

DRAW SOMETHING PEEKING OUT
FROM BEHIND THIS TREE.

278.

FILL THIS FISHBOWL WITH
SOMETHING UNEXPECTED.

279.

COMPLETE THE DOODLE BELOW.

280.

FIND SOMETHING BUMPY
OR FUZZY IN YOUR HOUSE
AND DRAW IT HERE.

281.

WHAT DO YOU THINK OF WHEN
YOU HEAR THE WORD "AIR"?
DRAW IT IN THIS SPACE.

282.
WHAT WILL YOU LOOK LIKE 50 YEARS FROM NOW? DRAW YOURSELF.

283.
DRAW A SANDCASTLE OUT OF DOTS. USE A YELLOW MARKER AND TAKE YOUR TIME.

284.
IMAGINE SOMEONE OR SOMETHING FLOATING ON THIS CLOUD. DRAW WHAT YOU SEE WITH A PENCIL AND USE CRAYONS TO ADD COLOR.

285.

DRAW A HORIZON LINE LOW DOWN IN THE FRAME. NOW YOU HAVE A BIG SKY. IMAGINE AND DRAW WHAT IS HAPPENING. USE COLORED PENCILS.

286.

YOU ARE A SPACE EXPLORER. DRAW WHAT YOU SEE OUT OF THE SPACESHIP'S WINDOW.

287.

IT'S NEW YEAR'S EVE AND YOU'RE AT A FIREWORKS DISPLAY. DRAW WHAT YOU SEE IN THE SKY.

288.

MANY ARTISTS LINK DIFFERENT FEELINGS OR SOUNDS WITH SPECIFIC COLORS, SHAPES, AND LINES. TRY IT YOURSELF...

SHADE AN ANGRY COLOR.

DRAW A QUIET SHAPE.

MAKE A SILLY LINE.

290.

DRAW YOUR FAVORITE FAMOUS PERSON FROM HISTORY. IT COULD BE AN INVENTOR, A SCIENTIST, AN ACTIVIST—JUST AS LONG AS THEY INSPIRE YOU.

289.

CUT SOME WHITE PAPER INTO FOUR SEMICIRCLES (SMALL ENOUGH TO FIT INSIDE THE SQUARE ABOVE). USE A BLACK MARKER AND MAKE LOTS OF DIFFERENT LINES OR MARKS ON EACH ONE. THEN ARRANGE AND GLUE THEM IN THE SQUARE.

291. TAKE A WALK OUTSIDE OR IMAGINE A PLACE FILLED WITH NATURE. NOTICE ALL THE DIFFERENT TEXTURES AND RECORD SOME HERE.

292.

AMERICAN ARTIST MARK ROTHKO IS KNOWN FOR HIS "COLOR FIELD PAINTINGS."

TRY IT YOURSELF. PICK THREE DIFFERENT CRAYONS AND COPY THE ROTHKO-INSPIRED EXAMPLE BELOW. MAKE THE EDGES OF THE RECTANGLES FUZZY AND MESSY, AND DON'T BE AFRAID TO LET THE COLORS RUN OVER EACH OTHER SLIGHTLY.

293.

CREATE YOUR OWN DOT-TO-DOT DRAWING. DRAW A FAINT SHAPE IN PENCIL, THEN ADD DOTS AND NUMBERS AROUND THE OUTLINE IN PEN. ERASE THE PENCIL. NOW TRY DRAWING THE SHAPE AGAIN BY CONNECTING THE DOTS.

294.

DRAW A HORIZON LINE HIGH UP IN THE FRAME. NOW YOU HAVE A SMALL SKY AND A LARGE AMOUNT OF LAND OR WATER. IMAGINE AND DRAW WHAT IS HAPPENING. USE COLORED PENCILS.

295. FILL IN THE FACES BELOW. EVERYONE IN THE WORLD IS UNIQUE, SO TRY TO REFLECT THIS. ADD GLASSES, SCARS, FRECKLES— CELEBRATE THE DIVERSITY AROUND YOU.

296.

FIND SOME SMALL OBJECTS AND TRACE AROUND THEM IN THE SPACE TO THE LEFT. TURN EACH OBJECT INTO SOMETHING NEW OR JOIN THEM TOGETHER. USE A PENCIL FIRST AND THEN ADD COLOR WITH MARKERS.

297.

BLUE, GREEN, AND PURPLE ARE COOL COLORS, WHILE RED, YELLOW, AND ORANGE ARE WARM COLORS. IN THE FIRST BOX, DRAW SOMETHING WARM USING COOL COLORS. THEN DO THE OPPOSITE IN THE SECOND BOX.

298. WHAT WAS THE PRETTIEST THING YOU LOOKED AT TODAY? WHY?

299. DESIGN A FLAG. WHAT SYMBOLS AND COLORS WILL YOU CHOOSE?

300.

LOOK AT YOURSELF IN THE BACK OF A SPOON. CAN YOU SEE THAT YOUR REFLECTION IS A BIT WARPED? TRY DRAWING WHAT YOU SEE.

301. DRAW A HOUSE MADE OUT OF AN UNEXPECTED MATERIAL—SUCH AS GOLD OR CANDY.

302.
DRAW SOMETHING INSIDE THIS MAGNIFYING GLASS.

303. ADD SOME OBJECTS UNDER AND ON TOP OF THIS BED.
USE A PENCIL TO DRAW THEM AND ADD COLOR WITH MARKERS.

304. LOOK CLOSELY AT YOUR TOOTHBRUSH. DRAW IT IN PEN IN THIS SPACE.
ADD SOME TOOTHPASTE TO THE BRUSH.

305.

LOOK AROUND YOU RIGHT NOW. CAN YOU SEE ANY REFLECTIVE (SHINY) OBJECTS? LIST THEM HERE.

306.

WITH A PENCIL, DRAW A SMALL PICTURE OF YOUR HEAD AT THE TOP OF THE RECTANGLE. NOW DRAW YOURSELF A NEW AND WACKY BODY. IT COULD BE THE BODY OF A ROBOT, OR BE MADE UP OF HOUSEHOLD ITEMS, SUCH AS A WASHING MACHINE.

307.

DRAW SOMETHING THAT HAS BEEN HIDDEN INSIDE THIS LOCKET FOR 100 YEARS.

308.

FILL THIS SPACE WITH AS MANY SPIRALS AS YOU CAN.

309.

A "BIRD'S-EYE VIEW" PERSPECTIVE MEANS LOOKING DIRECTLY DOWN AT SOMETHING FROM ABOVE. FINISH THIS BIRD'S-EYE VIEW OF A DAY AT THE BEACH.

310.

CREATE A PICTURE MADE ENTIRELY OF DOTS BY DIPPING THE END OF AN ERASER-TIPPED PENCIL IN PAINT.

 AVOID SMUDGES! KEEP THIS BOOK OPEN UNTIL THE PAINT HAS DRIED.

311. GIVE THIS CHAIR HUMAN LEGS!

312. DRAW LOTS OF HANDS IN THIS SPACE: GLOVED HANDS, BIG HANDS, HAIRY HANDS, TINY HANDS...

313.
FRENCH-AMERICAN ARTIST LOUISE BOURGEOIS ONCE CREATED AN ENORMOUS SCULPTURE OF A SPIDER. SHE THOUGHT SPIDERS WERE LOVEABLE, PROTECTIVE CREATURES. USE A BLACK PEN TO DRAW A SPIDER WITH LONG, SPINDLY LEGS TOWERING ABOVE THE FIGURE IN THE FRAME.

314. WHAT ARE YOUR FIVE FAVORITE COLORS?
MAKE A RAINBOW HERE USING ALL OF THEM.

315. DRAW FOUR CIRCLES. NOW TURN THE CIRCLES INTO FOUR DIFFERENT THINGS.

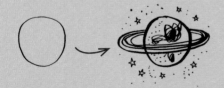

316.

FIND A LEAF, OR A PICTURE OF ONE. LOOK AT THE COLOR, SHAPE, AND TEXTURE. DRAW AND COLOR IT BELOW.

317.

WHAT IS THE TASTIEST BREAKFAST FOOD YOU CAN THINK OF? DRAW IT HERE.

318.

CREATE A PATTERN IN THIS BOX INSPIRED BY YOUR FAVORITE FRUIT. WHAT WOULD YOU PUT THIS PATTERN ON IF YOU COULD?

PINEAPPLE PATTERN

319. FLICK THROUGH AN OLD MAGAZINE AND CUT OUT SOME THIN STRIPS OF PAGES THAT YOU LIKE. GLUE THE STRIPS DOWN INSIDE THESE CLOTHES TO CREATE A UNIQUE OUTFIT. DON'T BE AFRAID TO COMBINE CLASHING COLORS OR PATTERNS.

320.
DRAW FACES ON THESE ACORNS. WRITE THEIR NAMES UNDER EACH ONE.

321.
USING LINES, COLORS, AND SHAPES, DRAW THE SOUND OF A FIRE ENGINE SIREN.

322.

BE A COPYCAT! FIRST COPY THE CAT WITH A BLACK MARKER. THEN COPY THE CAT WITH A BLACK CRAYON. DRAW A STAR NEXT TO THE VERSION YOU PREFER.

323.

DRAW A MAP OF A PARK. IT COULD BE A REAL ONE OR A MADE UP ONE.

324.

DRAW LINES TO DIVIDE THIS BOX INTO FOUR SECTIONS. FILL EACH SECTION WITH A DIFFERENT COLOR. USE TWO WARM COLORS AND TWO COOL COLORS. DO ANY OF THE COLORS SEEM TO COME FORWARD?

325.

DRAW SOME STEAM
COMING FROM THIS
TEAKETTLE. USE A
COMBINATION OF
PENCILS, CRAYONS,
AND MARKERS.

326.

AMERICAN ARTIST ED
RUSCHA IS KNOWN FOR HIS
WORD PAINTINGS—WORKS
MADE UP OF SIMPLE SCENES
OR BLOCKS OF COLOR WITH
SINGLE WORDS OR PHRASES
OVER THE IMAGES.

TRY IT YOURSELF. PAINT
THE EMPTY CANVAS IN A
COLOR OF YOUR CHOICE.
ONCE IT'S DRY, WRITE OR
PAINT A WORD OR PHRASE
OVER THE TOP.

 AVOID SMUDGES! KEEP THIS BOOK
OPEN UNTIL THE PAINT HAS DRIED.

327. TAKE YOUR ART JOURNAL ON A WALK—EITHER OUTSIDE OR IN YOUR HOME. FIND THREE THINGS THAT ARE INTERESTING AND CAN FIT IN YOUR HAND. DRAW THEM IN THE SPACE BELOW WITH A PENCIL.

328.

DRAW SOME UNCOOKED SPAGHETTI IN THE FIRST BOX. THEN DRAW SOME COOKED SPAGHETTI IN THE SECOND BOX. USE COLORED PENCILS.

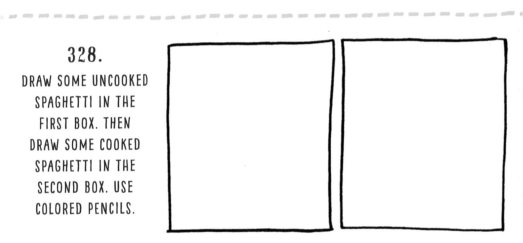

329.

THINK OF THE LAST PERSON WHO MADE YOU LAUGH—DRAW THEM HERE.

330.

THINK OF AN ANIMAL THAT HAS TWO LEGS. DO A LITTLE SKETCH OF IT.

331. DRAW A FAMILY OF ANIMALS IN THIS FRAME.

332.

CLOSE YOUR EYES AND,
WITH A BLACK MARKER,
CREATE A TREE USING ONLY
ONE CONTINUOUS LINE.

333. IT'S TIME FOR DINNER. DRAW YOUR
FAVORITE MEAL ON THIS PLATE.

334. FILL IN THIS PEACOCK'S TAIL. YOU COULD FIND A PICTURE AND COPY IT SO IT IS REALISTIC, OR YOU COULD MAKE IT UP AND USE UNEXPECTED COLORS AND PATTERNS.

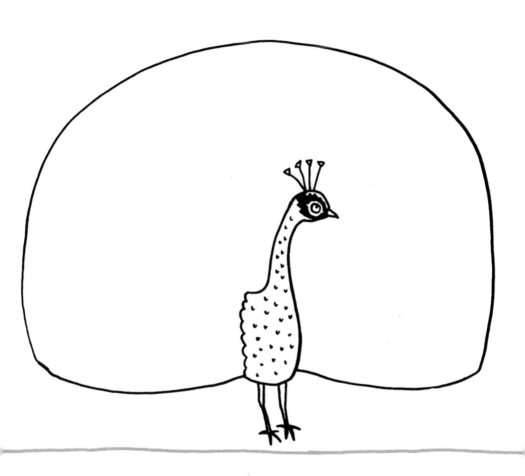

335.

LOOK AROUND YOU. WRITE DOWN FIVE THINGS YOU SEE THAT HAVE STRAIGHT LINES AND FIVE THINGS THAT ARE CURVED.

1. _____
2. _____
3. _____
4. _____
5. _____

1. _____
2. _____
3. _____
4. _____
5. _____

336.

USING A PENCIL, DRAW WHAT THE PERSON IS LOOKING AT.

337.

PICK A PENCIL THAT'S THE SAME COLOR AS YOUR EYES. WITHOUT TAKING YOUR PENCIL OFF THE PAGE, DRAW THE MOVEMENT OF YOUR EYES AS YOU LOOK AROUND YOU—YOU'RE TAKING YOUR EYES FOR A WALK!

338.

DO A SCRIBBLE DRAWING. USE BLACK MARKER TO DRAW SOMETHING MADE ENTIRELY OF SQUIGGLY, SWIRLY, MESSY LINES.

339.

LOOK AT THE PICTURE ON THE RIGHT. AN ORDINARY ICEBERG HAS BEEN TRANSFORMED TO SHOW A HEAD AND FACE BENEATH THE SURFACE.

TRY IT YOURSELF—TRANSFORM THE ISLAND IN THE FRAME BELOW HOWEVER YOU LIKE.

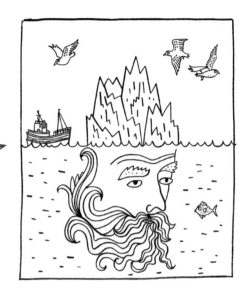

340. TURN THIS BOOK UPSIDE DOWN AND, WITH A PENCIL, DRAW A PERSON WITH THEIR ARMS UP. THEN TURN THE BOOK RIGHT SIDE UP AGAIN AND ADD A FLOOR TO MAKE THE PERSON BE DOING A HANDSTAND.

341. WHAT IS YOUR FAVORITE HOLIDAY? DESIGN THIS POSTAGE STAMP TO CELEBRATE IT.

342. WHAT DOES A RAINDROP LOOK LIKE WHEN IT HITS A PUDDLE? DRAW IT HERE.

343.

MEXICAN ARTIST FRIDA KAHLO IS FAMOUS FOR HER DETAILED SELF-PORTRAITS. SHE WOULD OFTEN DRAW HERSELF SURROUNDED BY A BORDER OF THINGS THAT WERE MEANINGFUL OR IMPORTANT TO HER, SUCH AS ANIMALS AND FLOWERS.

HERE IS A KAHLO-INSPIRED EXAMPLE OF A SELF-PORTRAIT.

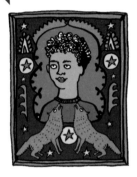

WRITE A LIST OF THINGS THAT ARE IMPORTANT TO YOU. THEN DRAW A SELF-PORTRAIT LIKE THE KAHLO-INSPIRED EXAMPLE ABOVE. INCLUDE DRAWINGS OF SOME OF THE THINGS YOU LISTED BELOW IN YOUR PORTRAIT.

344.

YOU'RE A CHEF AND YOU'VE MADE UP A NEW ICE CREAM FLAVOR. USE COLORED PENCILS TO DRAW IT. WRITE THE NAME OF THE FLAVOR ON THE CARD.

345. THINK OF A FOGGY DAY. FOG MAKES COLORS APPEAR DULLER. TRY DRAWING A FOGGY SCENE IN DULL COLORS SUCH AS GRAYS, BROWNS, WHITES, AND DARK BLUES. USE CRAYONS.

346.

DRAW A SPECIAL MEMORY IN THIS SPACE.

347.

DESIGN A NEW FONT AND WRITE YOUR NAME IN IT.

348.

WRITE DOWN TWO OF YOUR FAVORITE NAMES. NOW DRAW A PORTRAIT FOR EACH NAME.

349.

USING A PENCIL, DRAW A PERSON IN MOTION. FOR EXAMPLE, THEY COULD BE JUMPING, FALLING, RUNNING, OR SWIMMING. YOU COULD ADD MOVEMENT LINES, BENT KNEES, BEADS OF SWEAT, AND OTHER DETAILS TO SHOW THE MOTION.

350. DRAW SOME FOOD THAT SYMBOLIZES YOUR FAVORITE HOLIDAY.

351.

DRAW A RAINBOW FROM ONE CLOUD TO THE OTHER. BUT INSTEAD OF AN ARCH, MAKE THE RAINBOW A ZIGZAG OR WAVY SHAPE.

352.
DRAW YOUR
FAVORITE
SUPERHERO
IN THIS
FRAME.

WHY ARE THEY YOUR FAVORITE?
WRITE YOUR ANSWER BELOW.

353.

KEEP THE WRAPPER FROM A CANDY THAT YOU LIKE AND DRAW IT HERE WITH PENCIL. ADD COLOR WITH CRAYONS.

354.

CUT OUT A FACE FROM AN OLD MAGAZINE THAT WILL FIT IN THE FRAME TO THE RIGHT. CUT THE FACE IN HALF VERTICALLY AND GLUE ONE HALF DOWN TO THE LEFT OF THE DASHED LINE. NOW USE A PENCIL TO DRAW IN THE MISSING HALF.

355.

A NEW PLANET HAS WHIZZED INTO OUR SOLAR SYSTEM. USE COLORED MARKERS TO SHOW WHAT IT LOOKS LIKE.

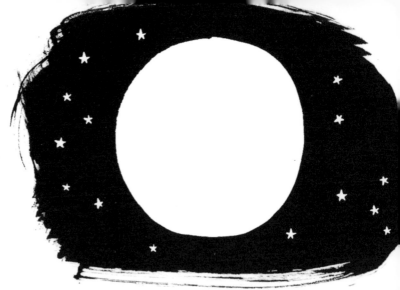

356.

DRAW A SELF-PORTRAIT. THEN LOOK BACK TO ACTIVITY 1 AND COMPARE THE TWO.

357.

PRACTICE DRAWING SMALL OBJECTS AND THEIR SHADOWS WITH A PENCIL.

358. PICK A WORD AND WRITE IT IN 3-D LETTERS BELOW. COLOR THE 3-D PARTS WITH MARKERS TO MAKE THE WORD STAND OUT EVEN MORE.

359.

THINK OF A PLACE YOU HAVE ALWAYS WANTED TO VISIT. DRAW YOURSELF IN THAT PLACE ON THIS POSTCARD.

360.

LOOK AT THE PICTURE. USING COLORED PENCILS, MAKE ONE SIDE DAYTIME AND ONE SIDE NIGHTTIME.

361. WITH A PENCIL, COPY THE PICTURE INTO THE EMPTY BOX, BUT REPLACE ALL THE ROUND SHAPES WITH OTHER CIRCULAR THINGS, SUCH AS EYEBALLS, WHEELS OF CHEESE, ORANGES...

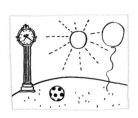

362. BRITISH COLLAGE ARTIST PETER BLAKE IS INSPIRED BY POPULAR CULTURE. HIS ART OFTEN INCLUDES PICTURES OF FAMOUS PEOPLE AND SYMBOLS.

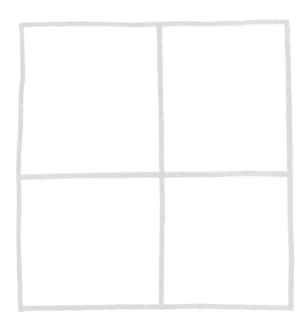

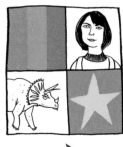

TRY IT YOURSELF. FIND DIFFERENT SYMBOLS, FACES, OR OBJECTS IN AN OLD MAGAZINE, THEN CUT THEM TO SIZE AND GLUE THEM IN THE EMPTY GRID. TAKE A LOOK AT THE BLAKE-INSPIRED EXAMPLE TO HELP YOU.

363. WITH A MARKER, DRAW SOMETHING TO ILLUSTRATE EACH WORD:

SNAP SQUEEZE SLIME

364.

USING A COLORED PENCIL, FILL IN THE SPACES BETWEEN THE BRANCHES. THESE AREAS ARE THE "NEGATIVE SPACE" (THE BACKGROUND) AND THE BRANCHES ARE THE "POSITIVE SPACE" (THE FOCAL POINT OF THE IMAGE).

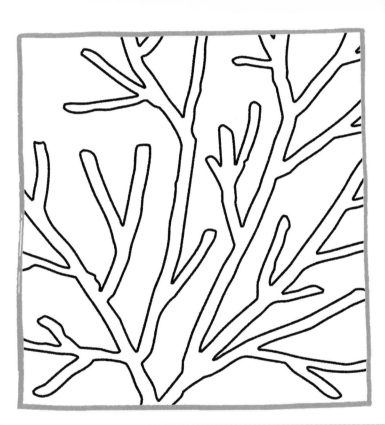

365. ARTISTS SIGN THEIR WORK SO THE WORLD CAN RECOGNIZE IT. FINISH THIS ART JOURNAL BY SIGNING YOUR NAME!

First American Edition 2020
Kane Miller, A Division of EDC Publishing

Text copyright © 2020 Susan Schwake
Design and layout copyright © 2020 Quarto Publishing plc

For information contact:
Kane Miller, A Division of EDC Publishing
PO Box 470663
Tulsa, OK 74147-0663
www.kanemiller.com
www.edcpub.com
www.usbornebooksandmore.com

Library of Congress Control Number: 2019952235

Manufactured in Guangdong, China, TT122020

ISBN: 978-1-68464-094-2

3 4 5 6 7 8 9 10

MIX
Paper from
responsible sources
FSC
www.fsc.org FSC® C016973